LOVE IS A
SPANIEL

summersdale

LOVE IS A SPANIEL

An Hachette UK Company
www.hachette.co.uk

Summersdale Publishers Ltd
Part of Octopus Publishing Group Limited
Carmelite House
50 Victoria Embankment
LONDON
EC4Y 0DZ
UK

www.summersdale.com

Printed and bound in China

ISBN: 978-1-80007-190-2

Substantial discounts on bulk quantities of Summersdale books are available to corporations, professional associations and other organizations. For details contact general enquiries: telephone: +44 (0) 1243 771107 or email: enquiries@summersdale.com.

♥ INTRODUCTION ♥

Those floppy ears, that luxuriant coat, their adorable puppy-dog eyes… is there anything sweeter than a spaniel? Let's face it, these super-friendly, family-oriented pooches are the perfect canine companion. Whether you have a spaniel of your own or just think they're the best pups in town, the adorable doggos in these pages will melt your heart and leave you feeling warm and fuzzy. So sit! Stay! And enjoy this delightful celebration of a truly loyal, lively and loving breed.

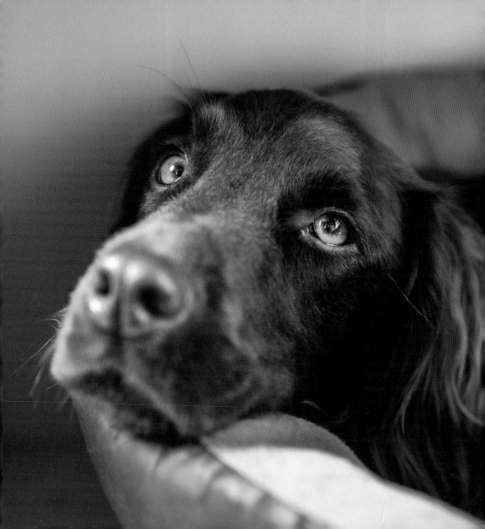

HOME IS
WHERE YOUR ♥
SPANIEL IS

DOGS ARE NOT OUR WHOLE LIFE, BUT THEY MAKE OUR LIVES WHOLE.

Roger Caras

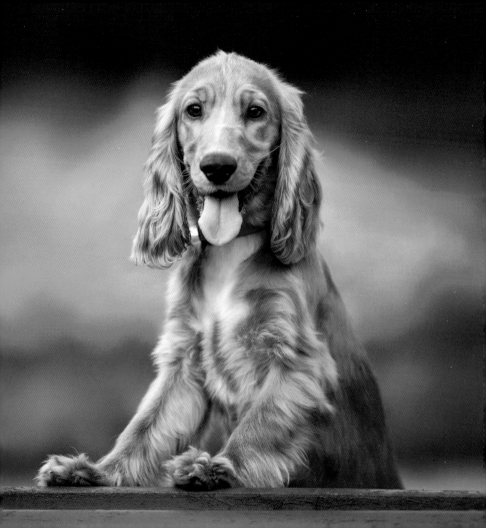

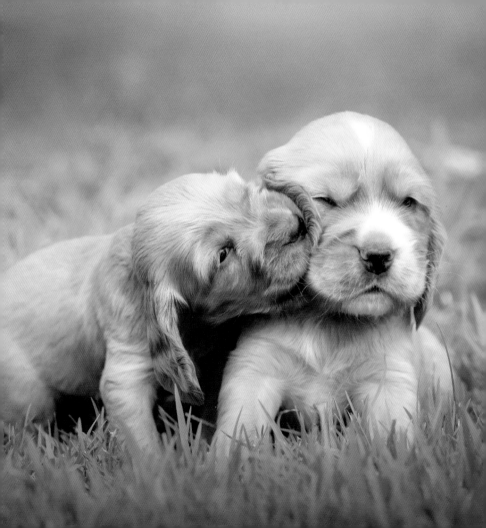

♥ I THINK IT'S ♥

PUPPY LOVE

EVERYTHING I KNOW, I LEARNED FROM DOGS.

Nora Roberts

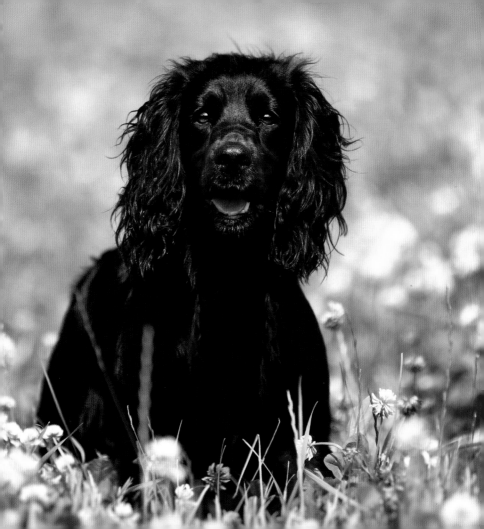

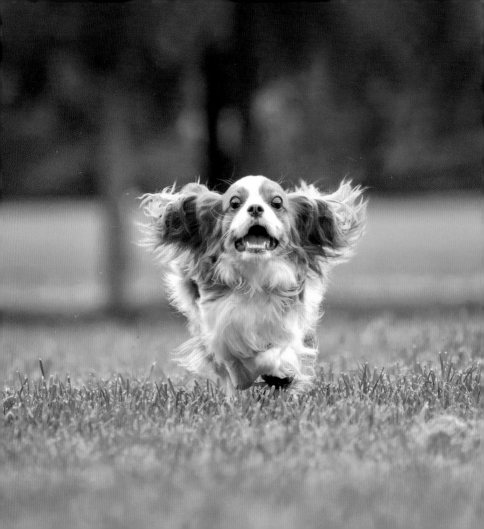

HAPPINESS?

♥ LET ME FETCH ♥

THAT FOR YOU!

THERE IS NO PSYCHIATRIST IN THE WORLD LIKE A PUPPY LICKING YOUR FACE.

Anonymous

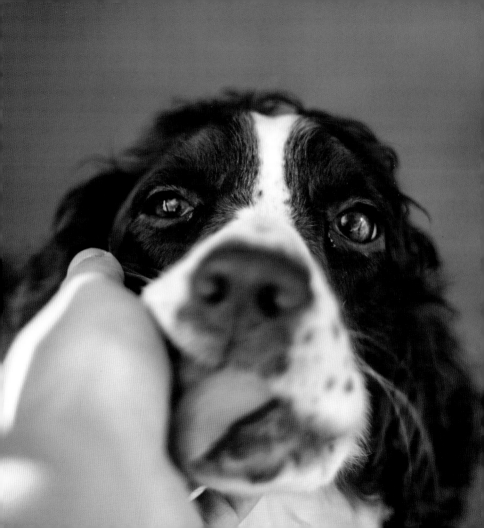

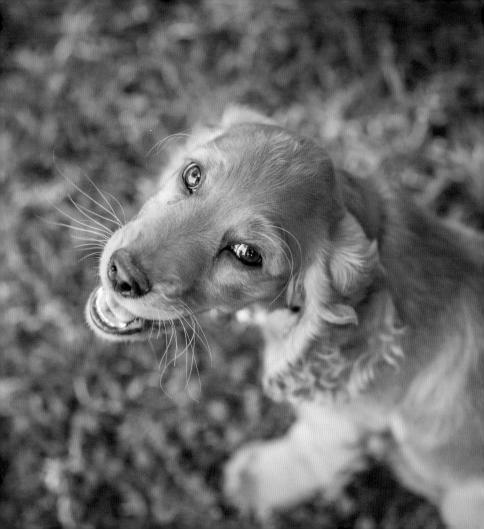

❤ *I RUFF YOU* ❤

SO MUCH

DOGS LAUGH, BUT THEY LAUGH WITH THEIR TAILS.

Max Eastman

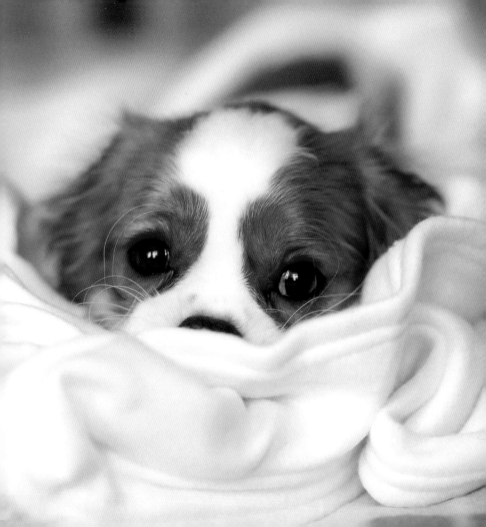

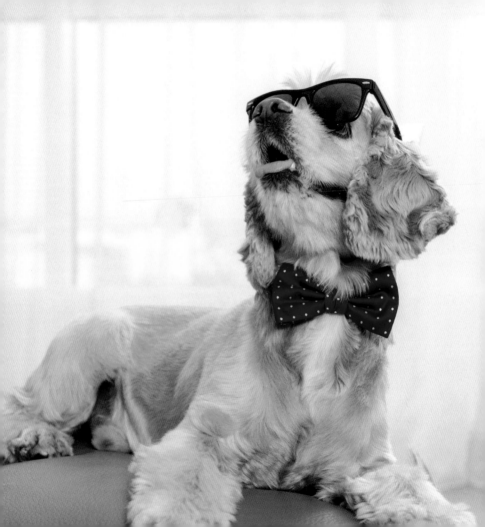

♥ I'M ONE CLASSY ♥

MOTHER PUPPER

I'VE SEEN A LOOK IN DOGS' EYES,
A QUICKLY VANISHING LOOK OF
AMAZED CONTEMPT, AND I AM
CONVINCED THAT BASICALLY DOGS
THINK HUMANS ARE NUTS.

John Steinbeck

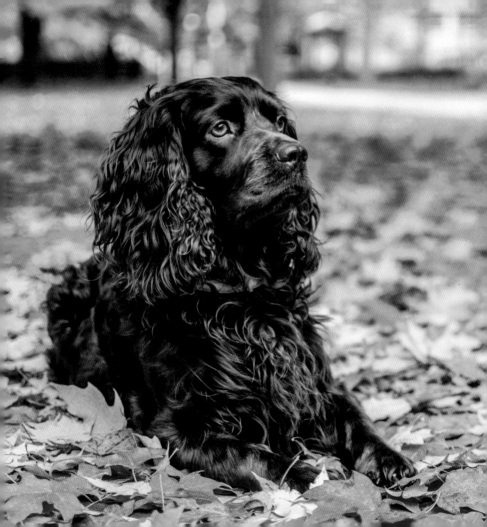

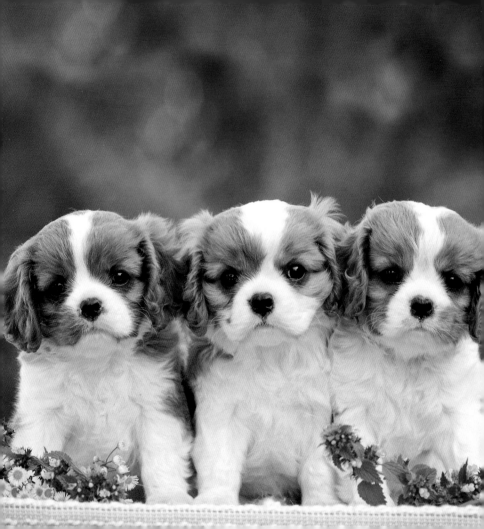

LIFE IS BETTER

 WITH A

SPANIEL

(OR THREE)

A PUPPY IS BUT A DOG, PLUS HIGH SPIRITS, AND MINUS COMMON SENSE.

Agnes Repplier

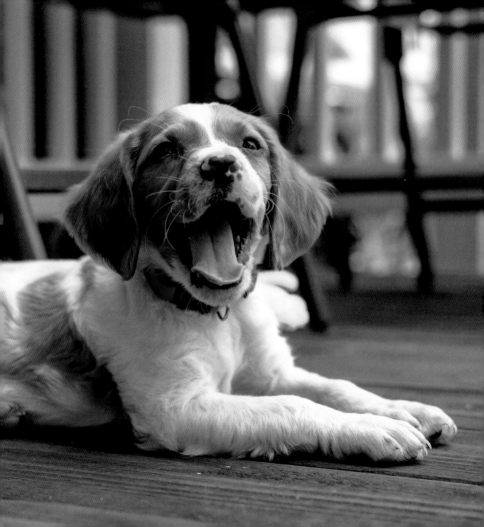

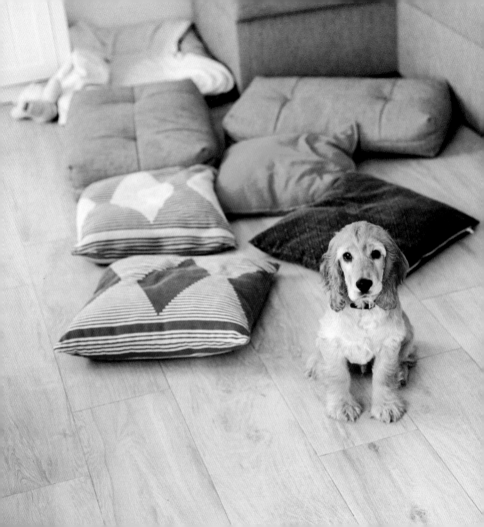

IT WAS LIKE THIS
WHEN I GOT HERE,
PROMISE!

THE GREAT PLEASURE OF A DOG IS THAT YOU MAY MAKE A FOOL OF YOURSELF WITH HIM AND NOT ONLY WILL HE NOT SCOLD YOU, BUT HE WILL MAKE A FOOL OF HIMSELF TOO.

Samuel Butler

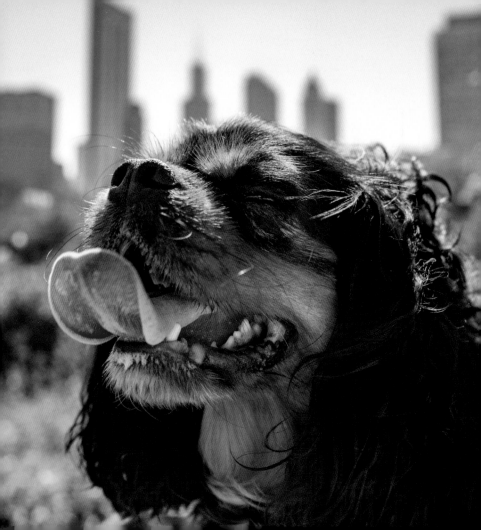

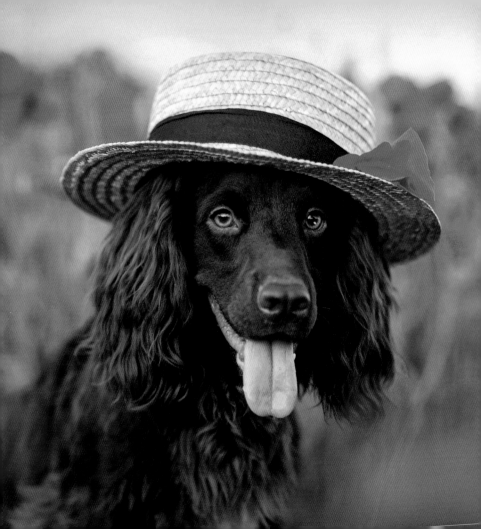

WHY YES, I DO

♥ LOOK RATHER ♥

FETCHING

WHY DOES WATCHING A DOG BE A DOG FILL ONE WITH HAPPINESS?

Jonathan Safran Foer

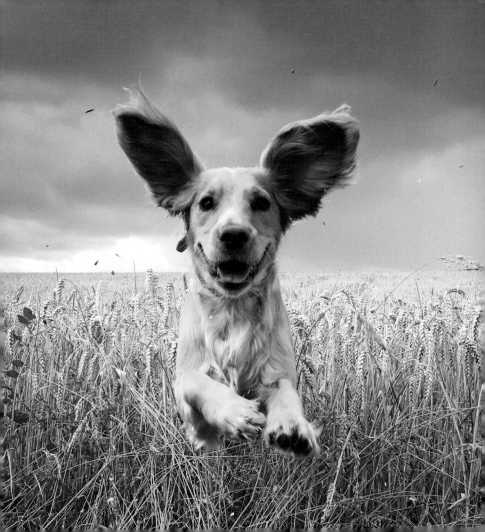

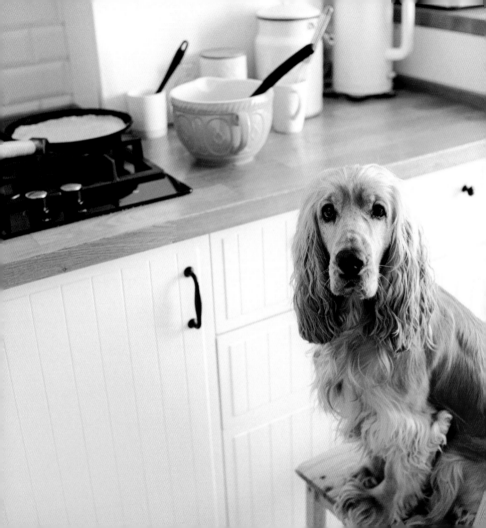

♥ TIME TO MAKE ♥

WOOFLES!

MY FASHION PHILOSOPHY IS, IF YOU'RE NOT COVERED IN DOG HAIR, YOUR LIFE IS EMPTY.

Elayne Boosler

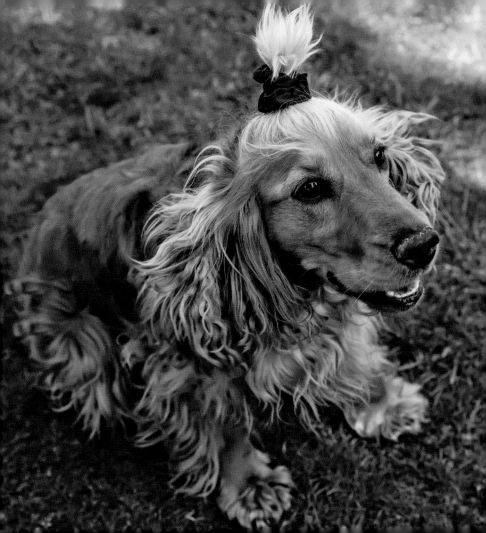

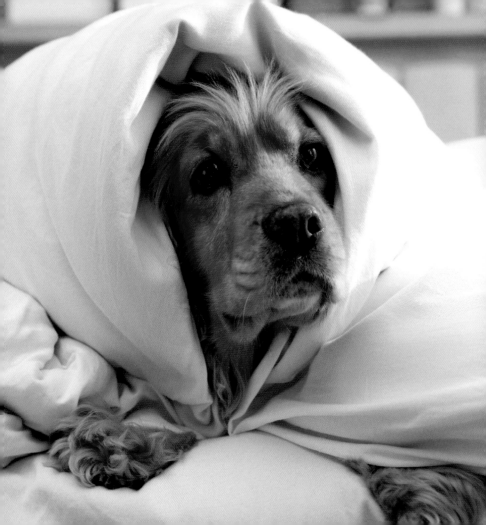

QUIT HOUNDING ME,

I'M SLEEPING!

A DOG IS THE ONLY THING ON EARTH THAT LOVES YOU MORE THAN HE LOVES HIMSELF.

Josh Billings

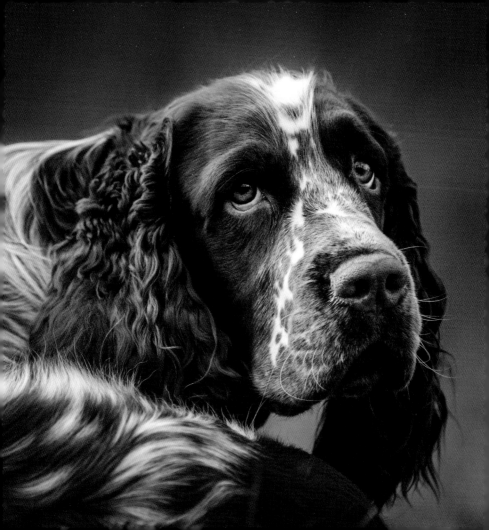

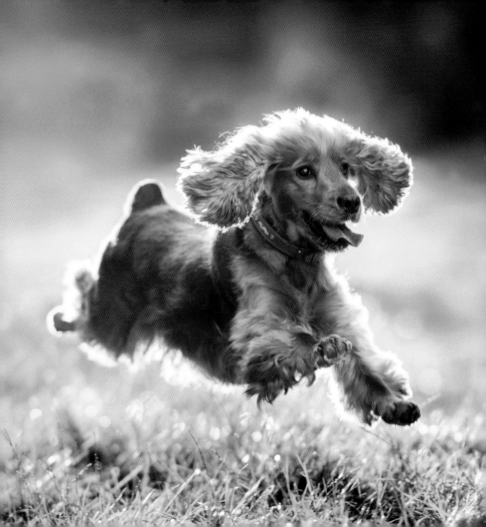

♥ TURBO MODE ♥

ACTIVATED!

DOGS ARE BETTER THAN HUMAN BEINGS BECAUSE THEY KNOW BUT DO NOT TELL.

Emily Dickinson

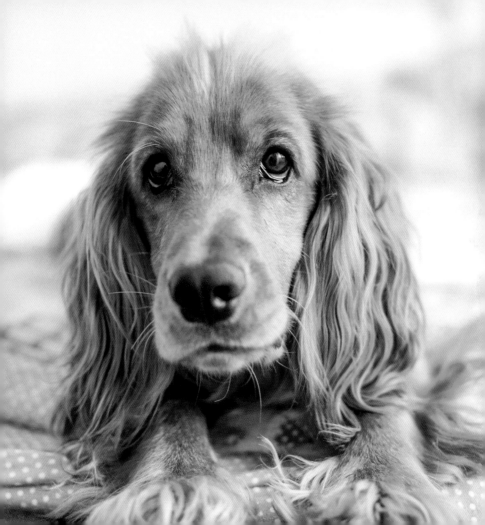

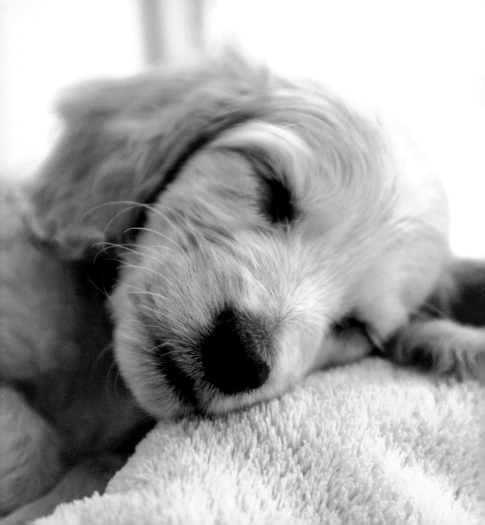

EAT, SLEEP,

REPEAT

NO MATTER HOW LITTLE MONEY AND HOW FEW POSSESSIONS YOU OWN, HAVING A DOG MAKES YOU RICH.

Louis Sabin

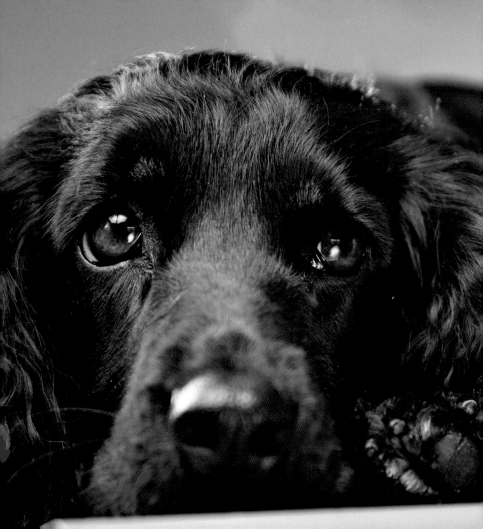

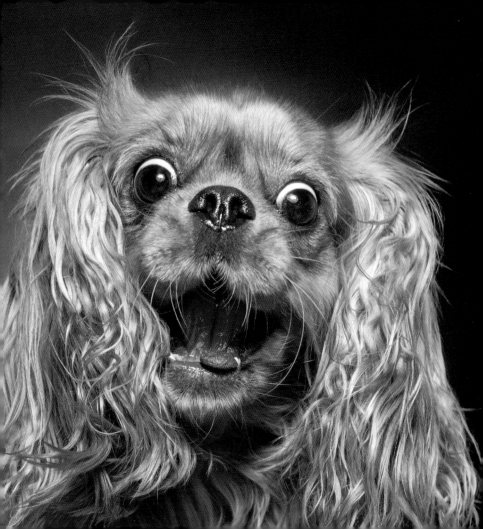

♥ IT'S BEEN A ♥

RUFF DAY

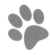

HAVING A DOG WILL BLESS YOU WITH MANY OF THE HAPPIEST DAYS OF YOUR LIFE.

Anonymous

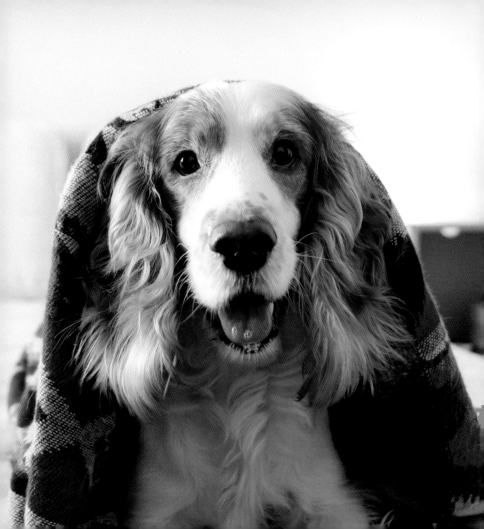

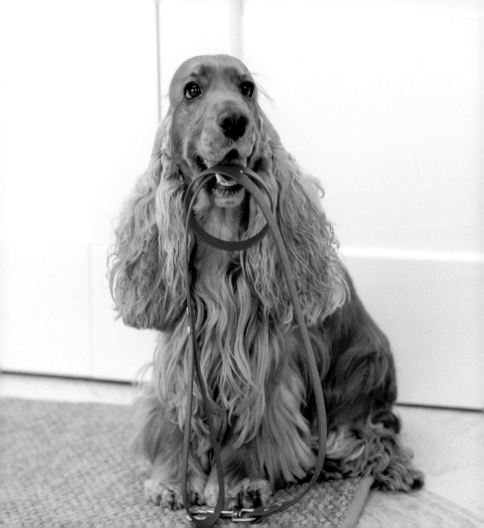

♥ DID SOMEONE SAY ♥

"WALKIES" ?

I AM I BECAUSE MY LITTLE DOG KNOWS ME.

Gertrude Stein

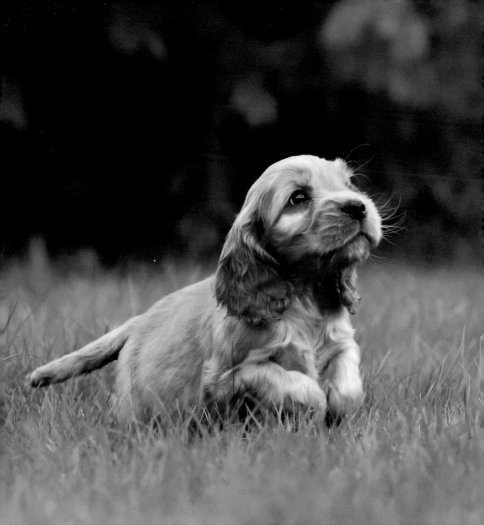

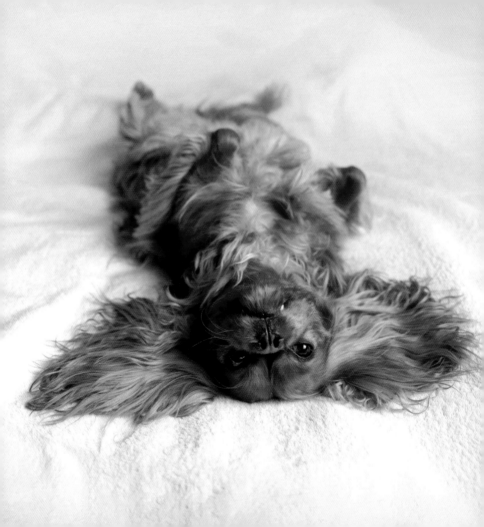

♥ GO AHEAD, ♥

I'M ALL EARS

DOGS HAVE BOUNDLESS ENTHUSIASM BUT NO SENSE OF SHAME. I SHOULD HAVE A DOG AS A LIFE COACH.

Moby

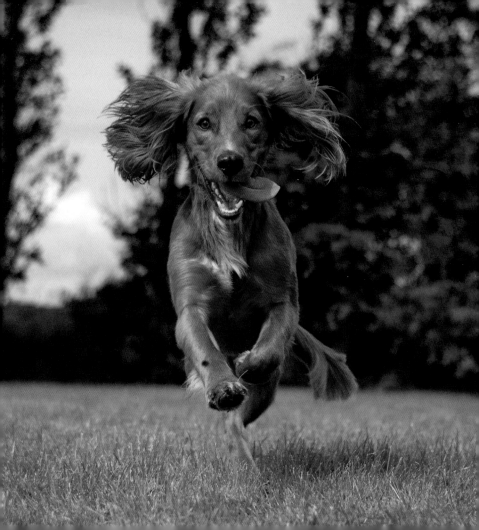

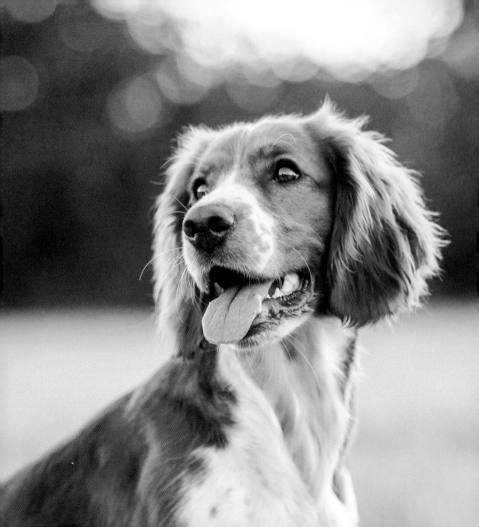

♥ I WOKE ♥

PUP LIKE THIS

DOGS ARE MIRACLES WITH PAWS.

Susan Ariel Rainbow Kennedy

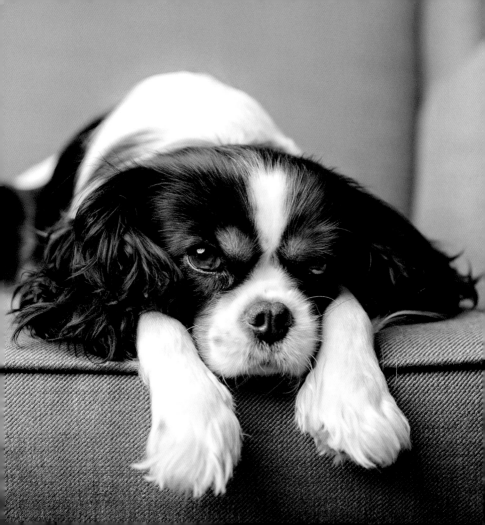

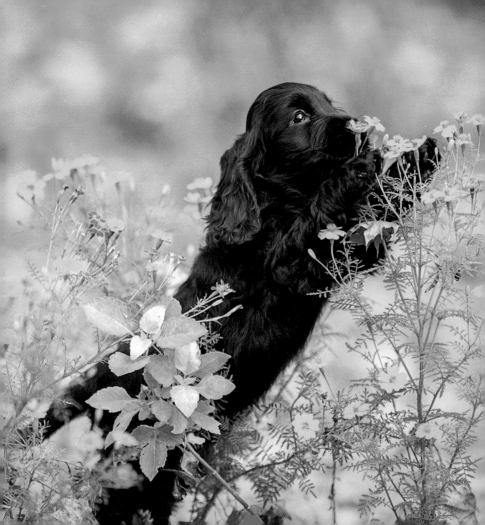

TAKE TIME TO

♥ STOP AND ♥

SMELL THE ROSES

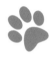

DOG, N. A KIND OF ADDITIONAL OR SUBSIDIARY DEITY DESIGNED TO CATCH THE OVERFLOW AND SURPLUS OF THE WORLD'S WORSHIP.

Ambrose Bierce

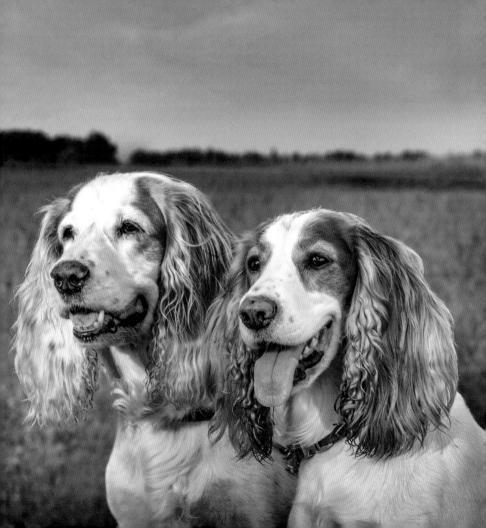

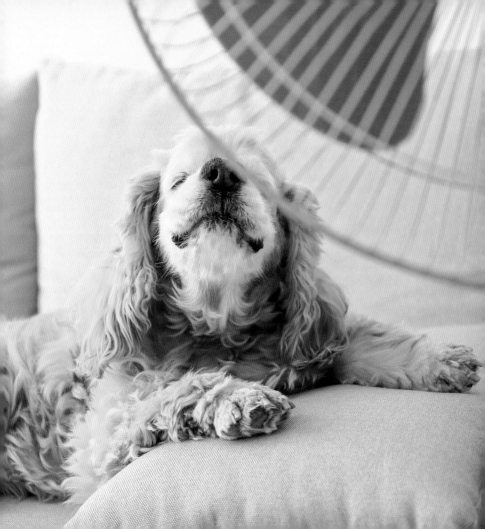

♥ I'M ONE ♥

HOT DOG

DOGS' LIVES ARE TOO SHORT. THEIR ONLY FAULT, REALLY.

Agnes Sligh Turnbull

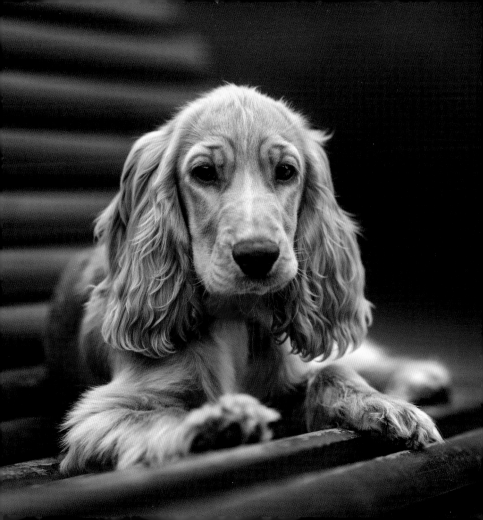

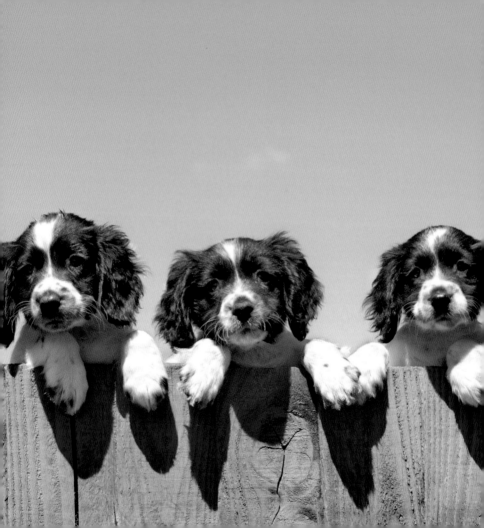

#SQUADGOALS

YOU CAN USUALLY TELL THAT A MAN IS GOOD IF HE HAS A DOG WHO LOVES HIM.

W. Bruce Cameron

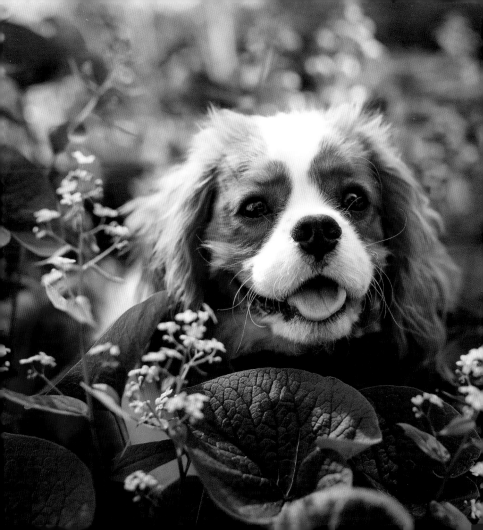

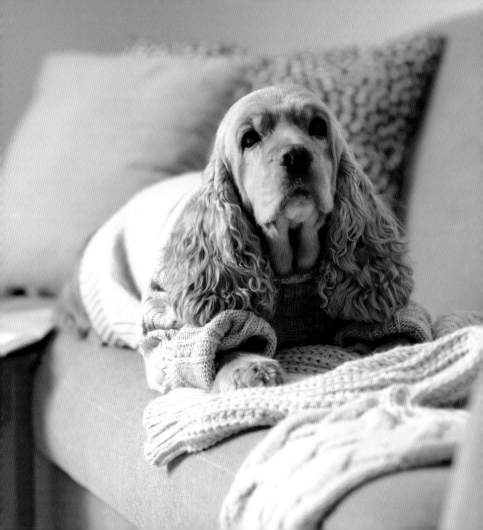

WHAT DO YOU MEAN I'M
♥ NOT ALLOWED TO ♥

SIT UP HERE?

YOU KNOW, A DOG CAN SNAP
YOU OUT OF ANY KIND OF BAD
MOOD THAT YOU'RE IN FASTER
THAN YOU CAN THINK OF.

Jill Abramson

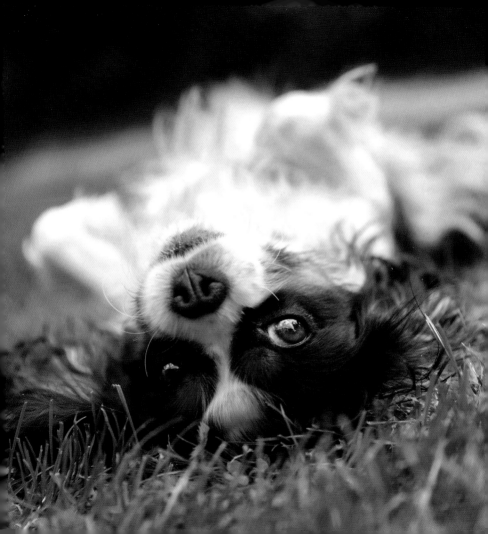

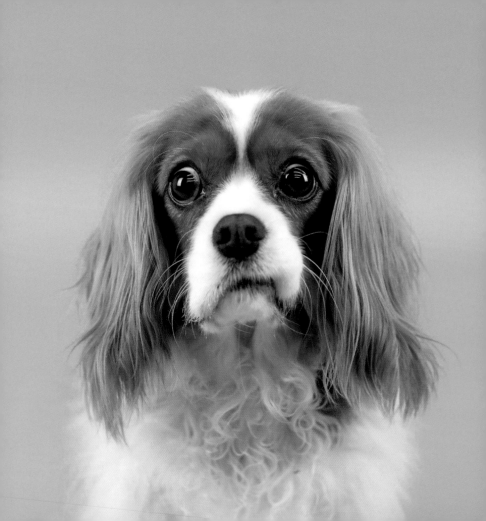

WHAT IF I NEVER
♥ FIND OUT WHO THE ♥

GOOD BOY IS?

THE DOG LIVES FOR THE DAY, THE HOUR, EVEN THE MOMENT.

Robert Falcon Scott

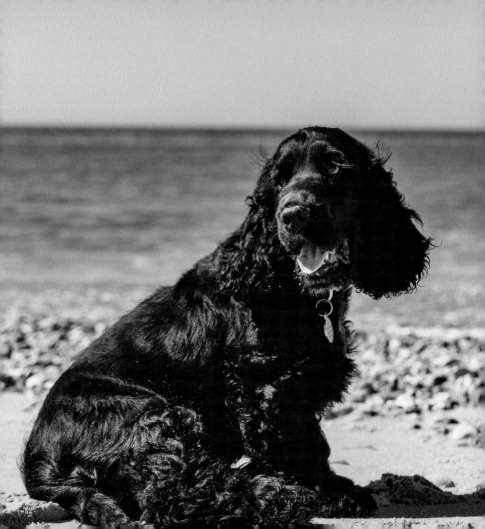

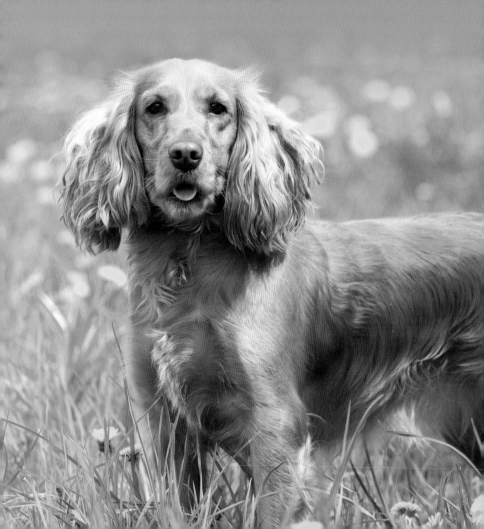

YOU SERIOUSLY
EXPECT ME TO
♥ FETCH IT ♥

AGAIN?!

OK THEN!

EVERYONE THINKS THEY HAVE THE BEST DOG. AND NONE OF THEM ARE WRONG.

W. R. Purche

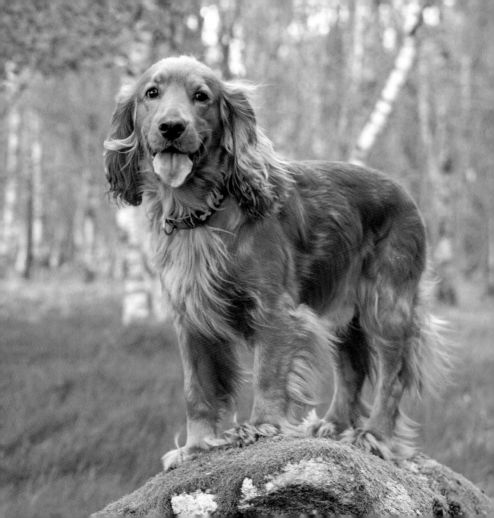

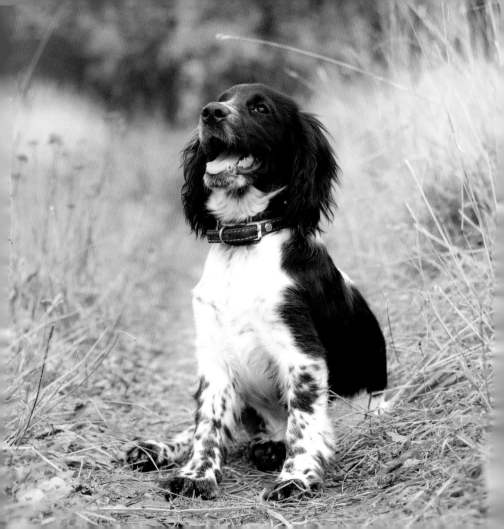

♥ YOU HAD ME AT ♥

"WOOF!"

THE WORLD WOULD BE A NICER PLACE IF EVERYONE HAD THE ABILITY TO LOVE AS UNCONDITIONALLY AS A DOG.

M. K. Clinton

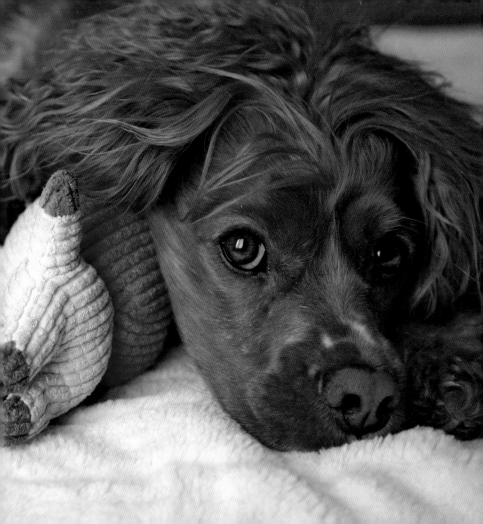

Have you enjoyed this book? If so, find us on Facebook at **Summersdale Publishers**, on Twitter at **@Summersdale** and on Instagram at **@summersdalebooks** and get in touch. We'd love to hear from you!

www.summersdale.com

IMAGE CREDITS